Midnight Blues

Written by:
Samantha Cunha

Illustrations by:
Sunny Wu

Book Cover Design by:
Idil Cinaroglu

Printed in the United States of America
First Printing, 2021

ISBN 978-0-578-83975-2

"Not all those who wander are lost. "

- J.R.R Tolkien

I. Entangled

Entangled

Entangled in thorns
of a poisonous tryst,
for my love is adorned
only in the dusk, the
dark, amidst the
midnight gloom.

We wither in the
eternal night,
for a shadowed
man disappears
as the ticking
clock strikes
noon.

Wildfire

Your silhouette is dancing
towards mine, our darkness
intertwined,
like decaying leaves
on a vine.

You are a wild, dancing
flame, swaying violently,
erratically, beneath the
evading slither
of moonlight.

Tonight, I seek the flames,
the burning red fire,
as mellifluous tunes
of heavenly desire,

Hum off in the distant
valley of mire.

Let's transcend our
yearning souls,
and elevate

Higher.

Fume

The fume of your nights
carry me high, bringing
the stars so nigh.

The fume, the swoon,
of your nights are
whistling for me,

For the fume of
your nights carry
me high, so high,

that the cobalt
sky is nigh.

I dare not look down,
for I refuse to
touch the ground.

For now, envelop
me in the fume of your
nights.

Embers

Falling embers in early December.
I watch with a glint in my eye,
as they burn bright
& die slowly.

As are we, for we
were meant to bleed,
but never to be.

We were like
a flower with no room
to
bloom, for it was
contained
in a windowless room.

You, enchanted me.
We
were meant to bleed, but
never to be,

Like falling embers,
in early December.

Transcendental

An oasis of
transcendental nightmares
& dreams while
a burnt coffee pot steams.

My fingers laced through
a flame, I burned myself,
and cursed his name
for there was pain
foreshadowed in
his intricate palm,
like a volatile storm
brewing before the calm.

There are heavy winds
blowing the palm
frond,

For both these
nightmares & dreams
contain silent
screams.

Don't awake me,
from these
nightmares-

nor dreams.

Invocations

Invocations of the
divine, wild, and free
through untamed
dances by the lonely
sycamore tree.

The sound of you-
a bittersweet,
euphony.

Hollow eyed love,
you are amorphous,

As you
shape shift each time
you leave.

Old Haunts

Old haunts drive me mad
as twisted faces of the past
form one dyad,
a million of you,
a myriad.

Rooted

Some days, I am shapeless,
dancing languid, and moving
so free. Some nights, I am firm,
and rooted into the earth
like a grounded tree. Some nights,
I break open, like the untamed sea.

Some nights, I am dreaming in
dark hues, amongst the
midnight blues.

Some days, I am humming
melodic tunes, and drifting into
a highway of endless dreams,
where nothing is as it seems,

Where a glowing light
off in the distance
gleams.

Some days, some nights,

I am somewhere, someplace
in between.

Ephemeral

I am an ephemeral spirit
turning off the daunting
light in your hallway of
wicked dreams.

We get lost in delirium
where nothing is as it seems.
I am an ephemeral spirit
on your fourth
dimensional plane,
with wild desires,

and heavenly
stars
in my veins.

Lamplit

Lamplit dreams
sing a symphony
to me in some
strange, new
cadence.

Form

My form seems
to be unclear,
amongst this
forsaken drear.

I become a
phantom,
haunting my
own hallways.

There is a freight train
running from me
once more,
turning me blue,
and leading me through

the unknown doors.

Superstitions

Superstitions crawling
in the late evening,
as dawn is approaching,
the moon fiending
to be reveled in.

A cackle off
in the distance.

Who lit that fire?
Who lit the flame?
Whom has these
desires
which must be tamed?

Superstitions
in the late evening.

Apparitions

I stand alone amongst the
cypress lined abyss

Apparitions of you

I feel your presence,
yet something is amiss

Apparitions of you

You transcend into
the kaleidescope night

You steal my fire
and my light

Apparitions of you

May

What may have been in the
midst of May, if the falling
leaves hadn't left us
to decay.

The roses of our love
stopped mid-bloom
that Sunday afternoon.

When summer eclipsed
through
the rear view mirror,
the ship got
rough and hard to steer.

What may have been in
the midst of May, if
the falling leaves hadn't
left us to decay.

The blue birds
stopped singing
our song, darling
it's time to keep
moving along.

Unmoved

I was unmoved by the mountains
that evening. I was unmoved by the
strangeness in your eyes.

I was unmoved by the Orion's
belt floating surreal in the sky.

I was unmoved by the
contemplation of god's existence,
unmoved by the "why".

I was unmoved by the fleeting
feeling, unmoved by the strange
texture & shapes on my ceiling.

I was unmoved that evening, for
there was nothing that could change
me, no wind strong enough
to sway me.

Tainted

Tainted blood,
overflowing flood,
dirty flower
refuses to bud.

Half- lit candles,
black crows
taking flight.

Running through
the blackened
shadows
to reach
the light.

Gilded

We were gilded,
not everlasting,
like true gold.

We were fading,
like the evanescence
of summer,
and beautiful
words.

We were fading, like
the sunset behind
a cascade of tormented
hills, fading, like
super 8 film stills.

We were gilded,
not everlasting,
like true gold.

Spring

When the dazzling flowers
of spring sprung, we danced
around the revolving sun.

The sun is burning high and
summer simmers closer
with each vibrant day,

Yet my mind feels like
a dreary winter's night,

In the midst of May.

Trace

I trace all my lost
homes on my arm,
hair slightly rising,
for
the winter is cold.

In Vain

The stars in your eyes are daunting,
they twinkle in vain.

The seaside abyss is haunting,
it twinkles in vain.

The needle is in some violet vein,
drifting on a daydream without
a name.

Compass less and nowhere bound,
we blow whichever direction
the tainted wind shall sound.

I sparkle, I gleam
amidst the silence-
an echoless scream.

We twinkle in vain,
as we grasp onto
the flickering light
to light our flame.

Vast

The passerby walks through
a landscape of infinite desires.

If all is lost in blackened skies,
is all lost in blackened eyes?

The passerby walks through
the landscape of infinite desire.

Vast cosmic darkness
turns on the light opposing
the boulevard,

Los Feliz at dawn.

Cars pass us by, jazz
blaring, electric and alive,
as am I.

Sing to me of this
dim night,

and revel in the vastness
without any fright.

Wild

Lilacs in my wild,
sun-kissed hair,

My dreams are
dying in the summer
air.

Fading

We sin only
to confess

Reverberation of
church bells

Echo in
a lonesome
alley

Fading skyline
while you
mainline

You no longer shine

You no longer shine

Awake

You, awake & ghastly at this
unholy hour, beneath my crescent
and waning moon.

I summon you
through the distant,
unwavering monsoon.

You, awake,

Ghastly at this
unholy hour, with no light
left to devour.

Don't reach for my light,
say goodnight,

if only for tonight.

Only you, are awake
at this ghastly hour,
with a strange omen,
and dark scour.

Softly

Dancing softly
in my crimson daydreams

Ultraviolet light
on distant moonbeams

Entangled in
twisted seams

Forlorn

I, like the vibrant rose
am delicate and soft
tonight
beneath
the gentle whispers
of light, peaking
through.

You, like the sharpest
thorn, are prickled
with scorn, and
madness
lights up your
eyes

Forlorn.

Vampiric

Vampiric energy drains my
synergy. The darkest moon
is howling, & night time
is the enemy.

For in the latent dusk,
my mind wanders, drowning
immeasurably in murky
waters,

With tantalizing
thoughts & endless
ponders.

II. Ephemeral

Lilac Dreams

I awoke in a field of lilacs
amidst dire dreams,
while unraveling slowly
at my velvet seams.

I grasp withering stems,
and prance in the field
with nomadic fiends.

I sway side to side,
one hand in the
earth, one hand
in the ethers.

One foot in the light,
one foot in the abysmal
dark.

I sway, sway,
sway, until I drink
 up the sky, and
the burning red night
fades into the day.

Merriment

The merriment of our youth
passes us like flickering flames,
wavering.

Follow me through the
violet lined valley
of adolescence.

Our guide lit up with mirth,
for he
knows what we may never see.

That the merriment of our youth,
fleeting, yet remains,
in
the glint in our wicked eyes,
growing colder, older,
but strong and wise.

Elixir

Don't drink me up!
No, not tonight.

I am not an elixir
for your taking,
I am not an elixir
of your making.

Don't drink me up!
No, not tonight.

For I am not
an elixir
of your making,
to cure your hands
from shaking.

Don't drink me up!
No, not tonight.

Leave me,
forsaking my light.

Don't drink me up!
No, not tonight.

Stoic

Open Window,
Arches high,
Moonbathing,
Taunting sky.

Stoic under
the stars,
like the silence
from passing
cars.

Reminiscent
of our
youth,

the stars,
and the humming
silence from passing
cars.

Barren

The trees are barren, the sky is ominous.
There's a violence amidst the white noise.
Open sky, you are vast, white, and
daunting.

My eyes are shut, gone is a presence,
once haunting. I dreamed it to be better
than
it was, taunting, myself, like a madman.

I could drive for hours down the main
drag
of this street, palm tree lined, 100 miles in
the dead, cold, blue night, driving
the bend with little light.

Instead- I will stay inside,
write my lines, and bide my time,
for the trees are barren, and the
sky quite ominous.

Running Mad

 We were running unhinged
and mad, like lost children of the
night.

The smoke obstructing
our hazy, rose-colored
visions & sight.
 The black ravens called
for us to follow- and we didn't
think twice.

For freedom comes
calling only to those whom
roll the dice.

Requiem

Requiem choir of voices
echo into the endless
night,
on a lonely road
void of light.

Sing to me an unknown
verse to
an unknown choir,
and
ring to the heavens
truth of our mad existence.

Life is ephemeral, as is
love,
the ghost flowers
embody this,

as their
only truth.

Epiphany

Let's fade away slowly
like an epiphany in cool spring,
or a rusted vintage ring.

Let's fade away slowly
like romance in June,
or the lingering of
some decadent,
sickeningly sweet perfume.

Let's fade away slowly, like the
afternoon, or the faintest
of a daytime moon.

The affliction

I saunter beyond the illusions
placed by my bedside,
by my feet.

The seeking spirals me
into the drumming of
a distant, enticing beat.

I dance between awake
and asleep.

The delusions fade, you
sing me a tainted lullaby
and weep.

For the beauty of the
unknown beat, will guide
us far from the illusions
placed at my feet.

Ivy Swinging

Ivy swinging, lush
willow tree singing
echoes near as resonance

Of your voice abruptly
appears, in our long,
twisting, never ending
hallway of drear.

Far out of sight,
far out of wits,
far out my mind,
and far out
of bliss.

Ivy swinging,
our willow
 tree
is singing.

Encompassing
tingling,
far yet near,
at last,

Our time is here.

Incantation

Driving slow motion by
a moonlit canyon.

The slow setting
sun, like an incantation,
a godly prayer.

I hear you summon
for me, yet
you're never there.

Through the blue hills,
vocals echo through
a singular tree.

The sky foreshadowed
what we could never
see,

That you and me,
doused in divinity,
an almost heaven,

That could never
be.

Celestial

I sought a celestial city
on a blue Tuesday, searching
for the other world, to be taken
away, and dissolve slowly, into
the earth's roots.

You sought beyond the
paradoxical nature of this realm
on a blue Tuesday, wandering the
streets
in search of a home.

You, searching, me longing,
and us meeting at the bend in the road.

Blue Tuesday, bloody sun
rising high, blue Tuesday.

I sought some distant paradise
on that blue Tuesday, the bloody sun
rising high.

Celestial city,
nigh in the night,
us meeting at
the bend in my road.

Transient Motel

There is a transient motel residing
by the sea, standing alone,
decaying, yet free.

Strangers come & go,
get high, leave dry, as
desolate palm trees sway
to bid the day goodbye.

There is a transient motel painted
faded light blue by the sea, vacant,
with no lock, nor key.

I will take you here so you shall see,
this transient motel is not
much different from me.

Opposing

Two trains
opposing tracks
a voyage to beyond
poetry in motion

Midnight Musings

My midnight musings will take me nowhere,
they will lead me pathless, nowhere bound,
floating high above the county line,
far from the ground.

These midnight musings blow in whichever
direction the elusive, tender wind
shall sound.

Tonight, no worries, of being lost nor found.

I venture out beyond & come back around,
for my midnight musings take me through
this vacant town.

Midnight musings, let's become pathless,
and nowhere bound.

Midnight musings, you mesmerize me,
leaving me spellbound.

Flooded

I live on the street
flooded with bloody
willow trees & opal seas.

I pass you like
a faint spirit, a spirit
whom occasionally
 passes through.

The trees cry for man has
cursed nature once
more, it's nothing new.

There is an opal ocean
near, I see it through
my rear view mirror.

The trees & I
sense the thickening
fear, the strange omens
that

The end may be
 near.

Remnants

There are remnants
of you in all I do.

Remnants of
your voice
in my sleep.

Remnants of
your raven
black
hair in my sink.

There are remnants of
you in all I do.

Remnants of your
shadow in my
tree lined view.

There is a road
which never ends,
you whom is never
there.

There are remnants
of you in all I do.

Mistress

You're a dancer
of the darkness,
a mistress
to the light.

You're a black
raven of freedom
yearning to
take flight.

You climb the most
maleficent mountain
in sight,
not fearful
of the greatest of heights.

You are a black raven
yearning to fly
from me- towards
a new sparkling gem,
a new unexplored
sea.

Wild Blue

The wild blue sea
breaks at dawn, parting
us from who we may
have become,

For here we are,
our bodies
strung out across
the golden sand.

You are untamed
& unbound
as the
sea breaks at dawn.

You look at me,
we can't stay long.

For the wild blue sea
will break us at dawn.

East Garden

The dreams of my east
garden are setting,
as the sky lightens
the void between
here and now.

I stand on the edge
of madness, the
precipice of danger.

Your
lost paradise
drags me down.

Roads

I recall all the roads,
never the destinations.

Leave the hallway
light on, as the
voice of eternal
darkness comes
along.

I recall all the roads,
never the destinations.

I recall all the feelings, never
the physical sensations.

Dandelions

Dandelions being
blown in the winter wind,
only of use
to the dreamers
& light-hearted
laughter of the summer.

Am I of any use to you
in the winter, when
I am a sinner-
not so light, not
so free, not so
reminiscent of your
youthful
daydream?

The dandelions are
being blown in
the winter wind.

I am hesitant
to let you in,
for I may not
be in bloom until
the summer.

Labyrinth

Your labyrinth,
your secret garden,
tucked away beneath
two willow trees.

Your secret garden
could light up a room,
or the skyline at noon,
but the unwavering doom,
it turns you blue.

Plume,
of black smoke rising,
in your labyrinth, your
secret garden,
tucked away below the
heavy clouds which loom.

Don't let them into
your labyrinth,
your secret garden,
for there is

no room.

Mesmerized

These nights will have
your visions dark blue,
your hair unkempt, and
your eyes stretching out to
the unknown void of cosmic
vastness.

In the distance, an asteroid.

In the distance, the moon
is full, and the waking world,
a remote hallucination.

These nights will have
you tangled in the what ifs,
tangled in the affliction
of looking beyond.

These nights will have
you mesmerized ,and lost
if you let them.

Transcendental

Foggy glass stained window

Church upon a hill of
abundance

Transcending space & time
light slowly flickers on,
eternal shine

Love is never
lost, just hidden

The veil is thin
& wispy

Floating
surreal
in the zephyr.

Swinging

You were swinging,
swinging
from the electric
rooftops of
Manhattan
at midnight.

Swinging
from women
to girl,
you
were swinging.

You were swinging,
like
a pendulum
in the wind,
never settling in.

Swinging,
mad and rootless,
no earth to
ground you.

Swinging from
the electric city to
the barren country

Swinging

Daylight Savings

The darkness seeps
into the room, settling
in by 5 pm.
My mind is bent,
the time is bent.

Clocks tick
backwards,
opposing the
circadian rhythm.

Kettle whistles,
evaporating
what could never
stay.

My mind is reeling,
the television is loud,
my pale hands
cold to the touch.

I miss the sunlight
and the trees,
I long to go
home.

Visions

Visions of
soul transcending
body

World between
asleep
& awake.

In this realm,
the holy sun
rises backwards.

For what is a
dream,
but an avenue
not yet explored,
or a road
not yet traveled.

Lightly

Tread lightly,
tread softly,
the storm
can wait.

Storm Rising

Storm rising, yellow sun,
dawn of the horizon.

Drive the curved
roads, I ride
all night.

Jazz, blues, magnetic muse,
shifty eyes lit up in neon hues.

We stand firm and tall
 in our heavenly youth.

Drive
the curved
roads, I ride
all night.

Lonely Trees

The trees, lonely and void
of spring rejuvenation.
The breeze, whistling,
sighing, disheartened.

I invoke the sun, the
trees, the whistling breeze.

We lay our delicate heads
where sun don't shine,
felt like 1979,
for ideas
of free love swirl
my mind.

Are the lonely trees
truly free, are
we truly free?
Is love to be shared?
Is love to be declared?

For like the trees,
I too, am void
of anything everlasting,
anything which
doesn't shift with each season.

Casting

Casting spells,
ringing church bells,
boots of leather,
and diamond
shells.
You were exiled,
like the unseen child,

Now,
You run wild.

Run to me, as some
new strange abode, so
far from home,

Devout to me, as your
only religion, leaving behind
a forsaken vision
of vespers
at sunset.

For you leave the subset,
and expand, becoming
whole.

Ancient Truth

We shed our skin, like
Egyptian snakes
seeking ancient truth,
in a land uncouth.

Falling through the peaks
and valleys,
we die for our youth.

Born into the arms of
a starry night
void.

Born for whom?
Born for what?

We die for youth,
We die for love.

Born for whom?
Born for what?

Temptress

Temptress
of the dark,
temptress
of the volatile,
erratic sea.

Wanderess
of the
winding path,

The chaotic
movement
leads my body
back to me.

I am the temptress
of the dark,
the wanderess
of the blackened sea.

Bay

The man who
kept his emotions
at bay,

Drowned in
them
all one
Winter's day.

Wildfire

At times, I am
like the wildfire,

Destructive,
full of rage,
smoldering.

Yearning to
eradicate the
natural state of
all which
surrounds me.

Burning, burning,
burning,

Yearning, yearning,
yearning

For change.

Infinitesimal

I am infinitesimal
beneath the
sea of stars.

My dreams
remain infinite,
and untethered
to this plane
of existence.

They tried to
steal my paradise,
and the twinkle
in my eyes.

I am buoyant
tonight,
and
infinitesimal
beneath
your holy light.

*They tried
to
steal my paradise.*

III. The Arise

Rising

Purple Flower
Rising

Steam from shower
Rising

Your breath in the snow
Rising

Midnight glow
Rising

The highest plateau
Rising

You and I

Rising

Raw

The raw, rough diamonds
still shine bright.

The lullaby of dire,
disastrous dreams,
still sing to me
eloquently
in the night.

The bluebird can see
with crystal clear
sight, through the
darkness
without
any fright.

For raw, rough
diamonds
still shine bright.

The road

Tonight, we are as free as
the night is long. Yellow lines
divide me, the sun
rises me.

The wind cries,
begging us
to take the day ,
forget the night.

Become who
you are,
forget where
you've been.

We are elastic, stretching,
out and beyond into
infinity,
like

the road ahead.

Blood Stained

Blood stained beach, I wander
through the intricate sand, and
discover a blood stained peach.

Is blood the union
of life and death?

Is blood the symbol for
the breadth- the depth
of our pain?

A symbol, an omen of how
the summer can still produce
storms and rain.

I devour the blood
stained peach, for I don't
fear the depth
of pain, I don't
cower nor hide
from
the summer rain.

Enchant

Come to me
in your winter.
Come to me in
your summer.

Come to me to
weather
your storms.

Come to me
to tame your sea.

Come to me
in your abysmal
black night.

Come to me,
you shall see,

I can
enchant you.

Reborn

We've died a million
times beneath the
destructive
celestial bodies.

You, reborn with
a glint in your eyes, and
the cosmic darkness carried
only by the heaviest
of nights.

We've died a million
times,
What's another
night?

Let's stretch ourselves
into the sky, and destruct
one more time.

Then, we shall
be reborn.

Summer

Summer was untimely
that year. Summer was
warm, filled with drear.

There was a feeling which
came and left me on
a midnight drive.

This feeling came in,
unwarranted, through
my passenger side.

The pine trees
in my reflection
a passerby,

As was that feeling.

It came and went,
so I still ride

For it all comes and
goes, like the arise
of a tide.

Worlds

Not all worlds
must be explored

Not all fires
to be lit.

We will not be
rewarded for
every road
we drove

Instead,
that which
we walked
away from.

For at any moment,
down the path,
we can always turn
around,

and
head back.

The Journey

Halfway through
the journey, beyond the
translucent wind
and sea-
a distant
clouded horizon,
unclear as could be.

I keep going,
and look behind me-
to recall all the
mountains
already trekked,
and the past

I must set free.

Waylaid

The trees waylaid me on
my venture to the beach
that gloomy Wednesday afternoon.

The trees spoke to me of finding
the unknown pleasures
cast out by the sea
at high noon.

The trees spoke to me, they
waylaid me, ambushed
me on that Wednesday afternoon.

For what is a plan if not
disturbed, and what is
a sky, without a flying, rising
bird?

It still exists, but
less in motion.

Just like the commotive
sea, the changes, the ebbs,
the flows, will set you
free.

Alchemist

There was an alchemist
in the dreary night,

He transmuted
my inner darkness,
& it vanished
into the iridescent light.

He handed me the
keys to the inner
kingdom,
and spoke
to me of heaven
on earth,

The voyage
of destruction
and rebirth.

Alchemist
of the night,
you
transmuted my
darkness into the
glowing light.

Devout

I am devout
to the gloomy hours.

I soak up the divinity
raining down
from heaven in the
falling, decadent
showers.

I inhale the
nonexistent
scent in the
field of flowers.

For the beauty
is in the *mundane.*

Majestic

Hands woven by fate,
the seeker rides off into
the majestic night.

Dusk slithers in through
the rear view mirror.

The past dries up in the
desert heat, smoldering , evading
into the burnt cement on the street.

The time is never, yet
the time is now.

Revel in the mystery,
the unknown magic,

and never in the
how.

Street Lights

Street lights cast a shadow
on your face.
A myriad of various hues.

Clocks tick eerily
slow.

You are lit up
by a heavenly glow.

A trip to the other
side of town.

River

Down the trudging road,
a crystal clear
river escaped
my vision,
for
it no longer
flowed.

When it comes,
it comes slow,
and runs like
eternal snow.

When it goes,
I embody the river
and let it
go,
for I understand
the universal flow.

The Answers

Seeking the answers,
the faded map,
from strangers
delight,
in the dead
silence
of the night.

They led me
on a
dangerous course,
with eyes closed,
driving full force.

How could I have been
so naive?

For the answers
always
lie within me.

The Light

Where the winding path
diverges and splits into two,

Where the wounds lay agape,
ghastly, open, & shining
in black and iridescent blue,

This is the space
where light
shines through.

Risings

All great risings began with
 the untimely
collapse, the fall, of some heaven,
or some distant kingdom.

Transmit

You tread unknown waters
like an ancient god. You
transmit the cosmos
with just one nod.

You walk the boulevard in
search of the others.

In search of friends,
foes, and lovers.

You burn fast
and so bright.

You search for the others, all
day and all night.

You tread unknown waters like
an ancient god, you see through
the facade.

You transmit the cosmos
with just one look.
You tread unknown waters
like an ancient god.

Moonflower

Moonflower,

We bloom
amidst the ruckus
and gloom.

Moonflower,

We bloom
in the darkest
corner of
the
room.

Moonflower,

When night calls,

The light falls,
darkness
is alive & crawls,

We rise high
& take on
a new form.

Reflection

I see myself in the
sweet honeysuckle blossoming
at noon.

I see myself in the
broken glass, shattered,
bleeding, which
spilled too soon.

I see myself in the reflection
of a vast, white, waxing moon.

I see myself all around me,

I see myself in you.

Becoming

Drenched in dirt
and kerosene,

I'm becoming

Drowning in
erratic waves,
lifting the sea,
rising from
the darkest tree

I'm becoming

Climbing the peaks,
riding the waves,
answering the call,
searching
in the void

I'm becoming

Soft Rain

Soft rain, soft jazz blaring blue.
My eyes , staring,
through
the window pane,
at you.

Soft light, so soft, so delicate,
so blue. No burdens to be bearing,
no tough battles to get through.

We let it all go
in the soft rain.

Soft light,
soft rain,
jazz blaring blue.

let it all go in the soft rain,
let it all drain,
in the soft, delicate
rain.

Birds of Paradise

Birds of paradise, prey on me.
Come on down, set me free!

Birds of paradise, flying high,
seeing what god knows, feeling the
speed in which the heavenly wind blows.

Birds of paradise, omnipresent,
like the true
descendant of heaven.

Birds of paradise, prey on me.
Come on down, set me free!

Imminent

Waiting patiently for the imminent
sunrise, waiting for the impending
seasons to shift.

We know it will happen as it needs to,
we know it will come as it pleases,
for the shift teases,

The beauty to come, and
 the rising of our
divine sun.

Romanticized

Life is meant to be romanticized,
let us relish in every sunset.

Sunsets are subset for hope
and awakening.

Let's drop our jaws,
in complete awe, at every
traffic light, majestically
shifting hues.

Let us see every dirty corner
of this city as an electric muse.

Life is meant to be romanticized,
let us relish in the ocean, as though
it has baptized
us, allowing us to be reborn, no
damage, not yet broken nor torn.

Let us swim through the moon,
away from scorn.

Let's romanticize this night,
let us romanticize this life!

Farewell

To all those whom I've lost on the road,
I bid you farewell with roses and gold.
Nothing gilded , only gold.

Even if your heart was
stoic, and cold. Even if my dreams
you sold.

To all those whom I've lost on
the road, I bid you farewell
with roses and gold!

I am beautiful and fleeting,
like poetry itself.

You could chase the storms-

and still arrive to your destination
whole.

CPSIA information can be obtained
at www.ICGtesting.com
Printed in the USA
LVHW031355280221
680187LV00033B/543